游 本 寬 影 像 構 成 展

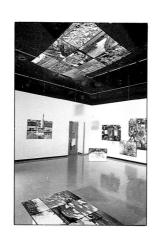

1988美國Ohio Seigfred Gallery.

序

　　本寬展出的攝影作品，呈現出深遠的文化意涵，色彩運用與圖像的刺激。他的影像排列與三度空間的展現方式，為攝影藝術中固有的大尺幅及缺少實質上立體感的有限效果，提出了有趣和複雜的解決方法。

　　影像的安排為觀者提出了美學上與文化上，種種辯證的可能性，然而它們並不是能夠被輕易解析的。這些由許多照片組合而成的表達形式，可被視為對色彩領域的研讀（活潑而突顯地運用強烈的紅色，乃作者所具有的中國文化本質之流露，而不是暴力的指稱，或政治的影射）。它們可被視為對空間的絕頂機智而生動探究，對開展出之空間的再審視，或反應極限藝術家所關注的造形與色彩。它們也可以被視為藝術家對當時美國景物之即興反應的筆記摘錄。作品的整體表現包括三度空間裝置，引發出觀者對其暗示性與實際的作品運用，以及暗示性與實際的色彩之深思。

　　這些三度空間與平面性的安排組合手法，一般是保留給繪畫，而今作者將它運用在攝影上，於是，以往對攝影之正確欣賞距離的假設，便立即被拋棄。額外的樂趣是，事實上這些排組照片中的每一單元，本身都具有清晰而完整的意涵與完美的處理技術。一般攝影展覽中的簡易觀賞過程，會被這種豐富的視觀效果所減阻。觀者被鼓勵先行研讀全幅組合所構成的圖案，再靠前來探究每一單張影像的細部與內容，而後向後退再來一次。每次所獲得的訊息與感動，都有深長的意義。

<div align="right">

俄亥俄大學攝影系主任
亞諾・凱森博士

</div>

影像解析影像　　　　呂清夫

　　相親看照片，證件用照片，新聞登照片，不外都是基於「有圖為證」的心裡。然則照片真是那麼可靠嗎？其實照片的影像不過是一種較具象的符號而已，它比起原始的象形文字並沒有高明到那裏去。

　　曝光的不足會使白天的影像變成晚上，仰角的拍攝會使山坡上的影像如同出現於平地。人的相片不過是生命長流中的一個切片而已，要以這個切片來代表整個長流，必如緣木求魚。一張香噴噴的烤肉照片對一隻狗而言，不過是一張枯燥乏味的紙張而已，只有人類才會對它產生口腹之欲，然則這是多麼的不真實啊！但是人類卻又習焉不察地堅信它的真實性，連攝影師都不例外。

　　然而，現在有一位年輕的攝影家，對這種真實性表現了他的問號與戒心，他就是留美五年的游本寬。對於影像的形色之美，游君早已運之於掌，但是單幅的美麗影像對他已覺不足，於是乃有影像組曲的大胆嘗試，並達到了美感的相乘效果。不過更引人入勝的，恐在於他的使用影像去解析影像，甚至批判影像。

　　例如十八張平放在地的有影子的影像，因為觀衆影子的參與，使作品多了一張，影像就是這麼不可捉摸，影像不過是一層表面（Surface）而已，就像符號一樣，摸起來都只是一個平面而已，把表面或平面想成實體或立體，豈非人類的不智？他又有十二張作螺旋垂吊的魚之影像，垂吊的影像即使有如悠游的魚群，但是只要你從嵌板的側面看去，你將可以看到，那些魚群通通都是沒有厚度的表面而已。另外，魚群的影像一邊彩色一邊黑白，兩種處裡將會給你十分不同的感受，而不同感受正透露着影像的模稜兩可。

　　所以不論你抱持的是人文主義也好，唯美主義也好，對於影像恐怕都要先有戒心，影像可能橫看成峯側成嶺。同時不論現實美善與否，為着影像的真實，你也不好預存框框，然後套在影像之上，你不要「喜則使用彩色，悲則採取黑白」，還是讓影像中性起來的好，游君如是說。也因為他觀念清新，所以樂於為序。

影像空間的際合　　　　陸蓉之

當藝術家／發明家享利・福斯・泰爾勃特（Henry Fox Talbot）在 1839 年發展成功正像／負像系統以來，從一張底片就能複印無數相片的方法，至今仍然延用著。而在 20 世紀廣泛流行的攝影，卻是美術攝影的最大敵人。現代藝術家自發明攝影之初起，即對迅速流傳的日常攝影，新聞攝影、廣告攝影……等非美術類攝影警惕戒備劃清界線。爲了區分與非美術攝影的不同，早期美術攝影便以模仿繪畫風格、主題、型式作爲一種僞裝的手法。反科技的，重視人手工製作的，所謂天才擁有天賦的種種偏見，終於因爲藝術家自我尊崇的自保意識，逐漸形成「藝術爲藝術而藝術」的經典道統，將現代主義的藝術引上一條力求「純粹」的遞減途徑。這項「純粹」的道統之說，也主宰了超過半個世紀以來的現代攝影藝術創作，直到 70 年代始轉換成另一種局面。

後現代攝影源起於六〇年代普普藝術家對應用攝影影像的態度改變。普普藝術家大膽地使用大眾傳播影像，反映消費文化的商業主義，直接從雜誌、電視、報紙、廣告、看板……剽取攝影影像——一個新的「後現代」現象，就在大眾傳播媒體影像泛濫成失去眞實的無限擬像（Simulacra）的經驗裏，走向電子媒體的新時代。70 年代藝術家，普遍放棄早先現代主義者純粹的美學觀點，而多元多向地實驗各種原已存在或尚屬新意的風格與媒體，打破風格與風格，媒材使用之間的限制，像野火燃燒乾枯草原般傳遍整個藝術領域。爲反對現代化主義者追求崇尚的統一宇宙性而強抑抹殺的七情七慾，反彈成許多極端強調個人意識理念情懷的「身體藝術」（Body Art），表演藝術（Performance Art），觀念藝術（Conceptual Art）一系的裝置藝術，偶發藝術（Happenings），甚至地景藝術（Earth Art or Land Art），往往均以攝影作爲記錄的工具，在作品完成或消失以後，攝影本身由記錄轉變爲代表觀念的藝術作品，將攝影容納爲觀念創作的一部分，

從此開始後現代攝影的另一章。後現代攝影，像繪畫、雕塑、戲劇等其他藝術項目一般，拆卸領域的邊界以後，呈現多種風格，媒材的融合或滙合並用，攝影技術，無異於運用一枝筆，一管顏料，一塊石，供藝術創作自由地應用發揮。在內容方面，不再抗拒，排除敍述性，作品不但可能含有隱喻性，而且具備故事性，攝影，不再是研究「是不是眞的」問題（指是不是眞的眞實），而在探討攝影究竟是「屬於那一種的眞實」。於是後現代攝影反映出的不再孤高非人化的神化仙境，而表現藝術家面對實際生活所產生的壓力，張力和感應，影像是種種破碎紛離經驗的拼合，極度商業化的環境且受制於傳播媒體的導向，權威逐漸淪落，原創的可能被大量源源湧現的「擬像」所淹沒。攝影藝術家無需擔任按下快門決定瞬間的記錄者，和其他媒體的藝術家一樣，在「擬像」的大海中浮沉，選擇，接納際合的機緣，或「權充」（appropriate）已然存在的眞實，是後現代社會裏日常生活中流通的共同語言。

游本寬作爲一位生長在東方文化環境，而在八〇年代成熟於西方的藝術家，他的攝影作品自然地顯現兩種文化背景際合所產生的複數因子。「純攝影」不可能饜食他創作的欲求，將攝影成品延展於三度空間的展示手法，理念上脫離現代主義追求「平面」（flat）的攝影侷限。多幅影像組合成件的作品，由於立體裝置的分割空間，產生前景，背景的新關係（懸在空中的作品視覺上重疊於週邊的作品），隨觀者的走動，使得組合成的影像一再產生新的視覺語言。和許多其他後現代攝影藝術家「不純粹」的特質一樣，游本寬的攝影作品，由於已經跨出「純攝影」的範疇，觀念的本身非常重要，而觀者與作品發生的觸應同等重要，作品由環境當時產生的應對爲詮釋。一種不斷衍生的可能性，使得游本寬作品有異於傳統記錄性再現的攝影（由快門按下的刹那決定結果），他的結果總因人因時因地而無盡改變，多重影像所暗示語義的組合可能，像玩

六合彩一樣難以預測。唯有他單一影像的製作，仍然取決於他個人「決定性的瞬間」，而非預設景的攝製（除了「水果照片」，除了少數的幾幅「權充」古畫圖片，看得出游本寬的美學基礎，深植於現代主義追求優秀崇高天才式的掌握「自動性」的機緣。自信中隱藏矛盾的本質，以唯美的語言合唱不安的悸動，無法妥協卻由藝術家對型式與色彩刻意加以控制。與大多數西方後現代藝術家勃起即宣洩的突兀和傾向於生活現實非常不同，游本寬表現出屬於東方古老傳流下來含蓄的理想化盼望，總是來生來世。

「水果照片」由十八張看起來有數字邏輯的單元組成，散自於幾何長方綠地上的水果，因為人的投影牽引出遊戲的可能性，而無法歸納出遊戲的規則，觀者嘗試尋找答案的企圖，只得像膠膜罩住相片一樣，被真空。「紅色染料＃4」九幅圖像當中的中心，彷彿觀者所在的定點，向週圍用長短鏡頭擷取景觀，無人境界強烈喻示人的視覺落處，楓紅與黃葉綠樹小白屋協奏悠雅的弦樂四重奏。「移動紅點」從紅色的鬱金香、紅色的T恤、紅色的布幔，紅色的色面繪畫到小小紅色的消防開關，視覺隨紅色移動的流程因一幅黑白的安迪‧渥荷畫像而受到干擾，集會的人群對比靜極的畫廊空間，和室內一角，日光和暈黃燈光的「唯一存在」對照，那「唯一存在」好像從另一時空挪移而至，黑白的渥荷像在暈黃燈光陪襯下觸動突發的哀悼情緒。「穿上一雙黑襪」具有強烈的戲劇氣質，人物動作彷彿從電影片段中被凝止的畫面，牆面上的日光燈管和一地落葉發散出寂寥訊息，位置的變化和取景距離角度的變化延續時間和故事的進展暗示，色調的處理涵有「空氣」和「光」的動感，是一幅靜止的動態畫面連續。「喂：蘇珊在嗎？」和「穿上一雙黑襪」一樣充滿戲劇性的故事暗示，分割而無法連貫的視覺語言，很難找到「蘇珊在嗎？」的答案。

「十九幅光的作品」實際上只有十八幅圖像，除了右三直行第2幅中央是看起來像人的半具像石刻以外，其餘十七幅均有攝影者的投影，那第十九幅因為展出場地燈光從背後將觀者的影子投射在這項組合上，才真正完成了第十九幅光的作品，是表達觀念性的有趣嘗試。「芝加哥地圖C-5」的作品題名指出地圖上的定點，線條在畫面上再切割原本由十五幅單元組成的集景，營造出靜與動之間人在穿梭的意象。「紅鶯鼓翅」畫面右端及下端邊緣，看起來像水泥板的拼合，像花圃的周邊，又像牆綠窗框，既似空中鳥瞰的取景，又似望向窗外的平視，而綠色的草地又和連接鄰圖的綠樹，連成一氣，如此時空兩者都有變化的組合——錯綜的透視角度，風動的樹叢和運動中的女子，權充挪用的雕塑黑白浮雕圖片，很容易聯想到由電視螢幕機所組成的電視牆，同時播放變動速度不一的各種畫面。「五月花二號」是此次展出中唯一社會批判性較強的作品，白色的花，映和白色的紙屑垃圾和踐踏草地的白色球鞋，是一幅「美麗」花朵控訴下溫和地暴露人類對環境不經意的破壞行為。「恐龍下樓梯」綠色樹叢的感覺對映黑白的恐龍遺骸和黑白樓梯間的照片，抱頭的石雕人像喻示危機的即將發生：恐龍下樓梯，必然碎身的結果，一叢鮮艷盛開的花朵，代表作者哀祭跌落喪生的恐龍，用詼諧的象徵手法探討生存的危機，有散文詩一般的情境。

游本寬的攝影作品，整體而言，時刻流露豐富的文學性，使得裝置手法所企圖表達的觀念性架構，受到敘事性的衝擊而不能突出彰顯。但是由小幅單元排列組合的視覺語言，切斷敘事的連續性，而際合機緣變化的無限可能，使得游本寬向傳統攝影提出的挑戰，得以在空間因視覺語言的交換而完成。以攝影作為創作媒體的選擇，游本寬所跨出的步伐，走向迎接變數的發展方向，應該在下一次的展出，再度啟示另一種面貌和另一種呈現方式。

游本寬作品的精神是超脫於混濁世間的純勢清逸。在這個紊亂失序的時代裏，他的特質和慌亂無關。

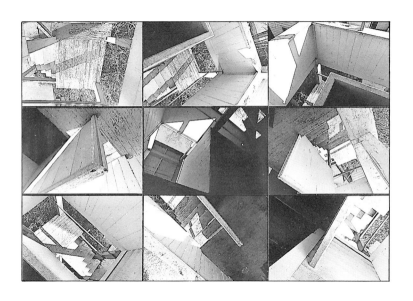

下樓梯的杜象──The Descending Duchamp　　144×97cm 黑白照片 B/W　1987

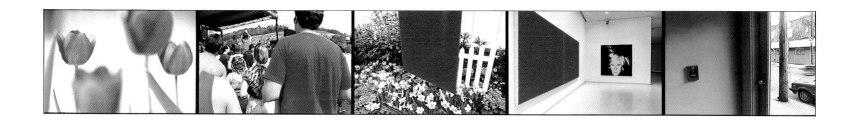

移動紅點——Moving Red　　240×33cm　C-print　彩色照片　1987

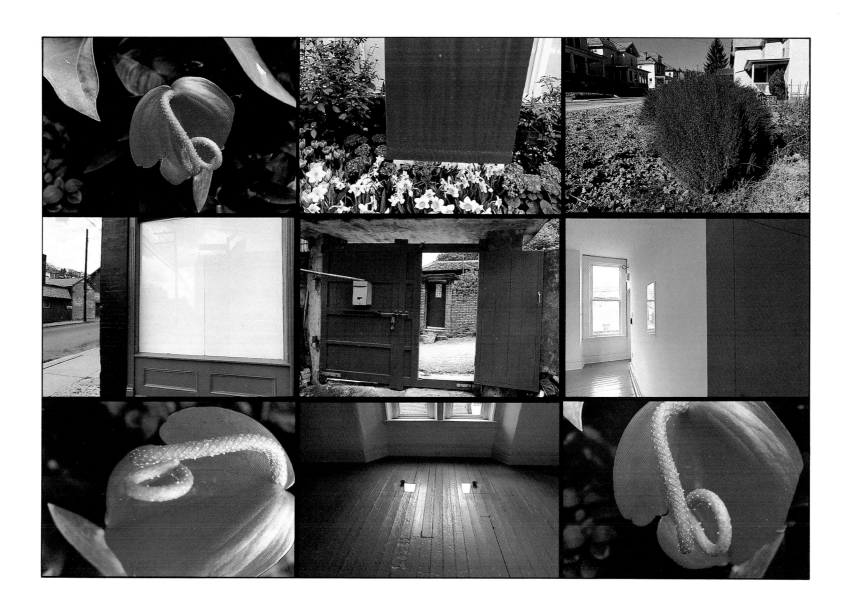

紅色染料No.5——Red Dye No.5　　144×97cm　C-print　彩色照片　1988

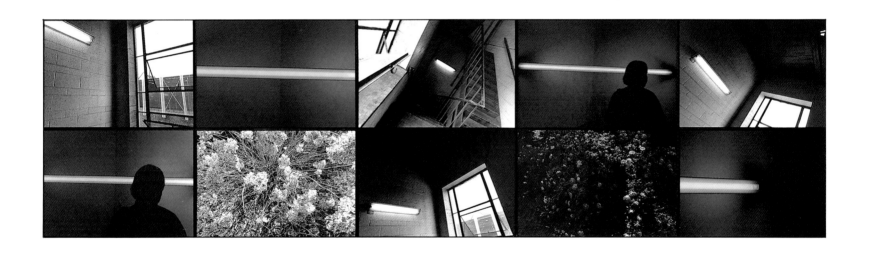

東方快車──Oriental Express　　240×65cm　C-print　彩色照片 1988

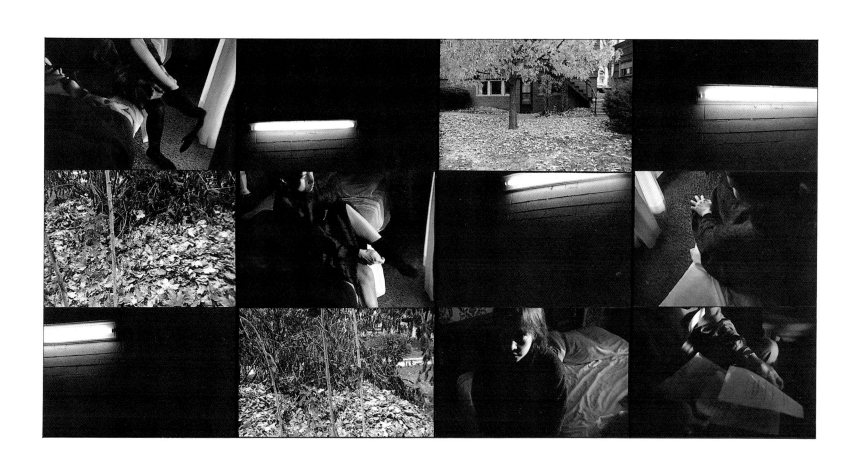

穿上一雙黑襪——Shrivel⋯⋯Pull　　192×97cm　　C-print 彩色照片 1989

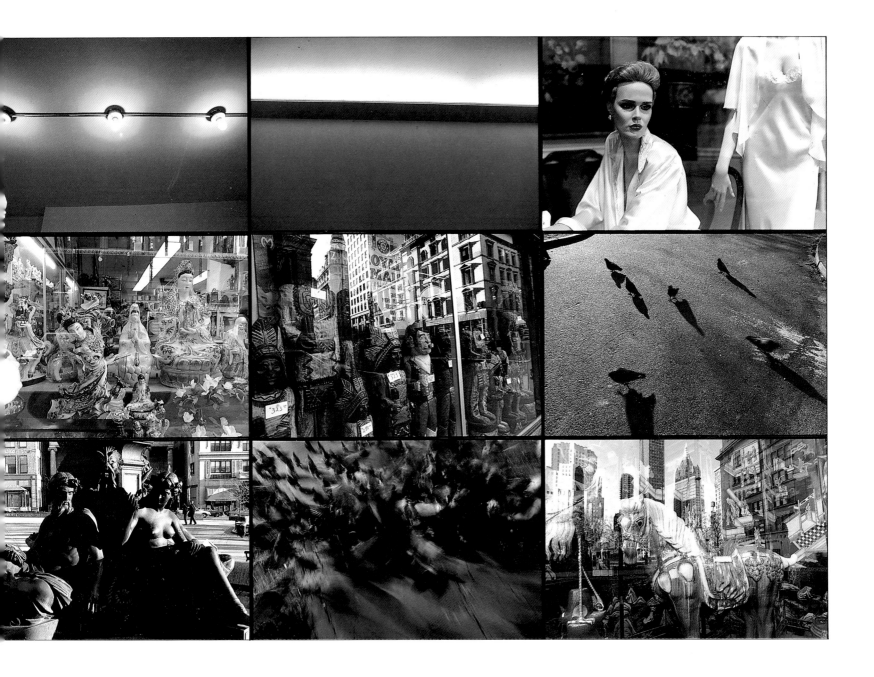

喂，蘇珊在嗎？——Hello, is Susan there ?　　　240×97cm　C-print 彩色照片 1988

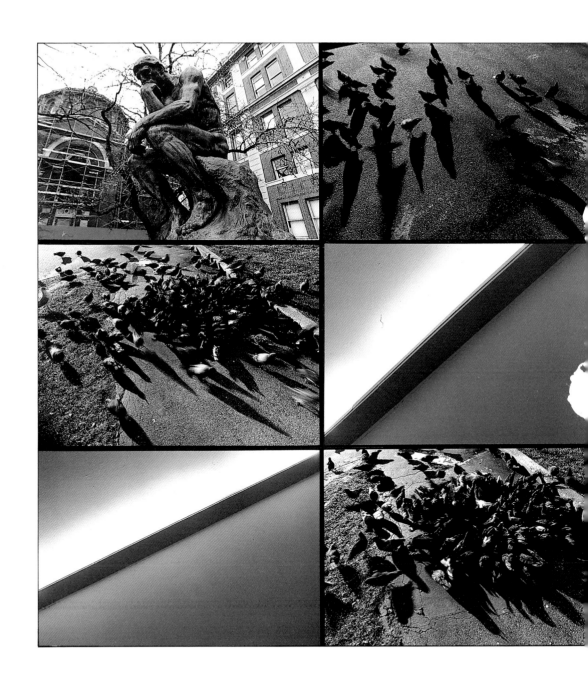

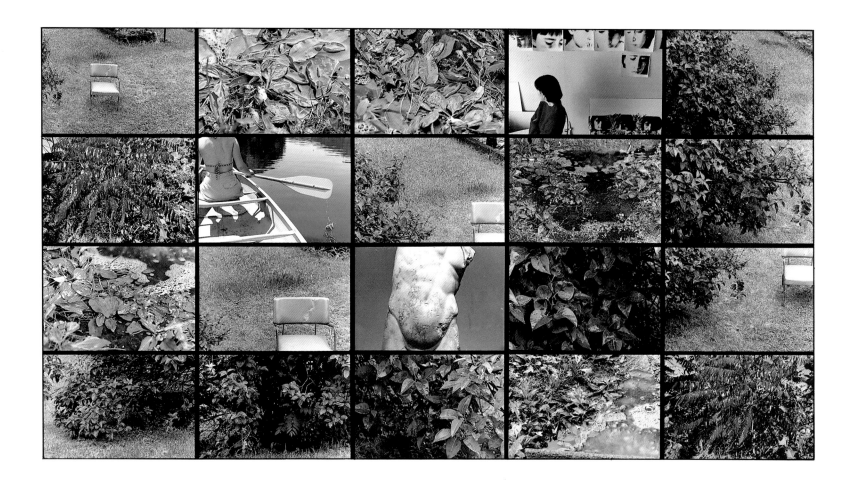

周五天氣預報：晴時多雲──Friday's Forecast: Partly Sunny　240×130cm　C-print　B/W　彩色、黑白照片　1988

播種者——Seed Sower　　288×97cm　C-print 彩色照片 1988

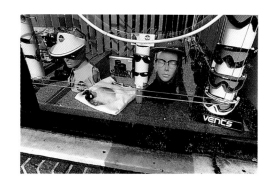
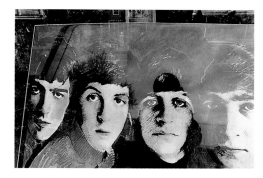
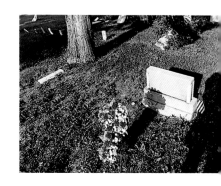

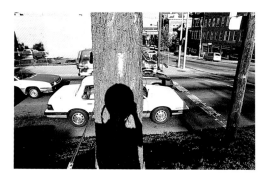

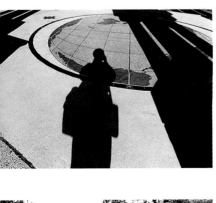 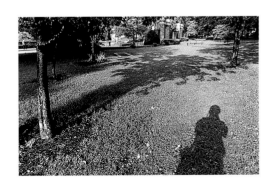 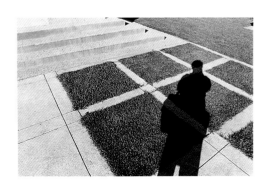

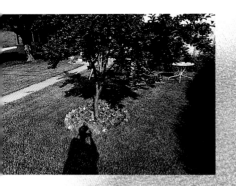 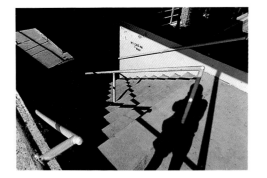

十九幅光的作品——Ninteen Photo-Graphs 18張16″×20″ C-print 彩色照片 1988

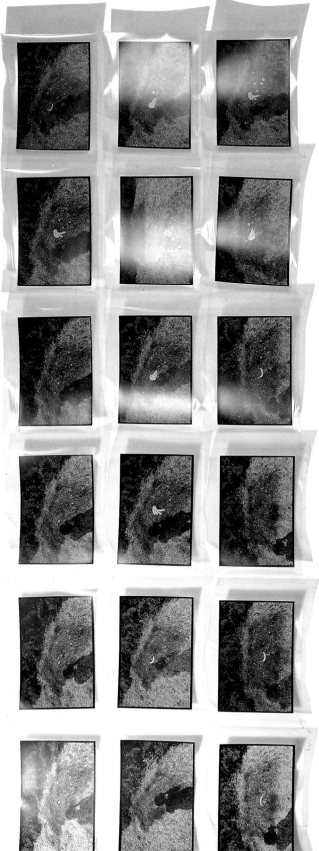

水果照片———Fruitshots　18張11″×14″　C-print 彩色照片　1990

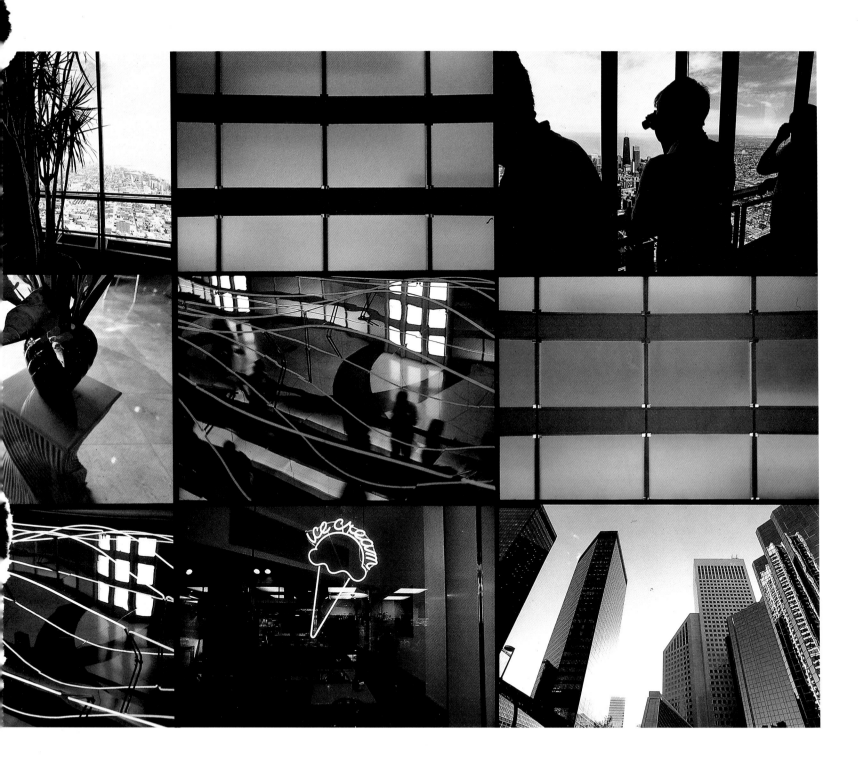

-5 240×97cm C-print 彩色照片 1988

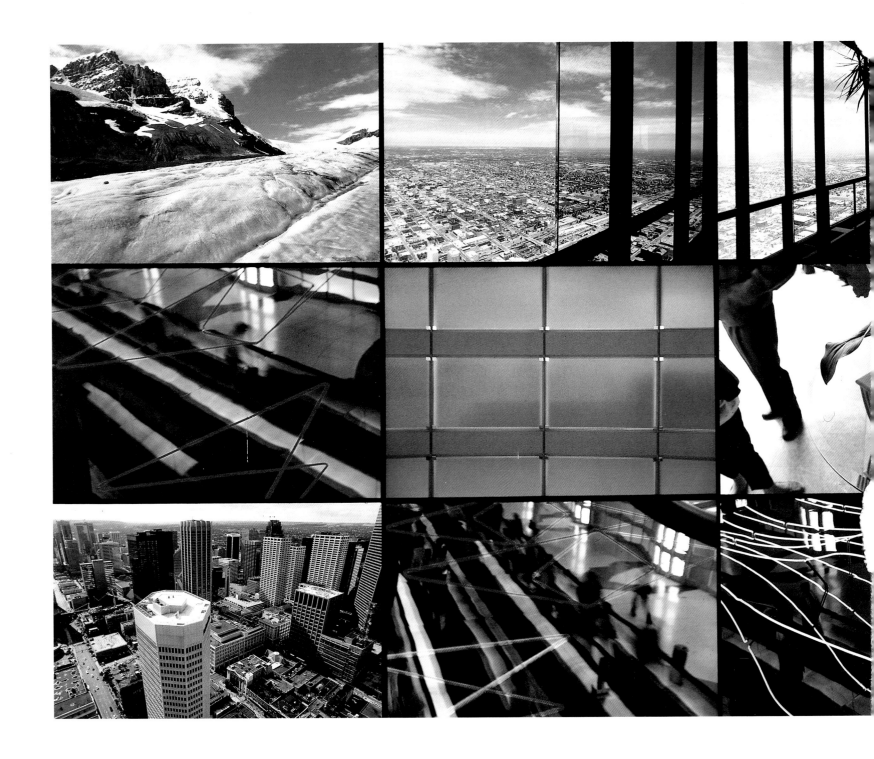

芝加哥地圖 C-5——Chicago Map C

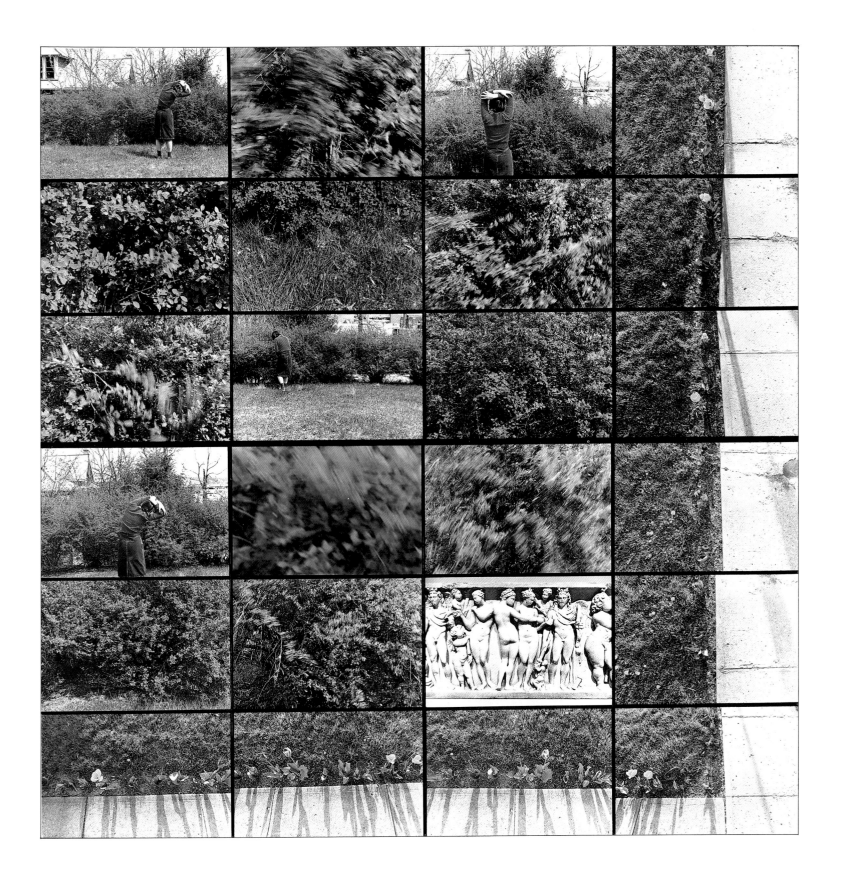

紅鶯鼓翅——Flapping Cardinal　　193×195cm　C-print & B/W 彩色、黑白照片　1988

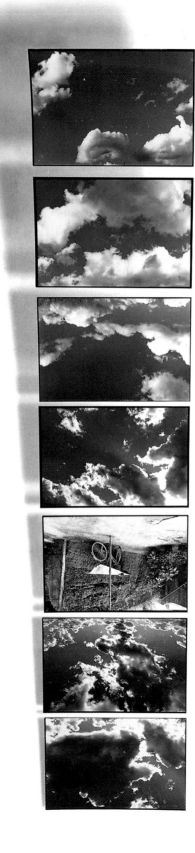

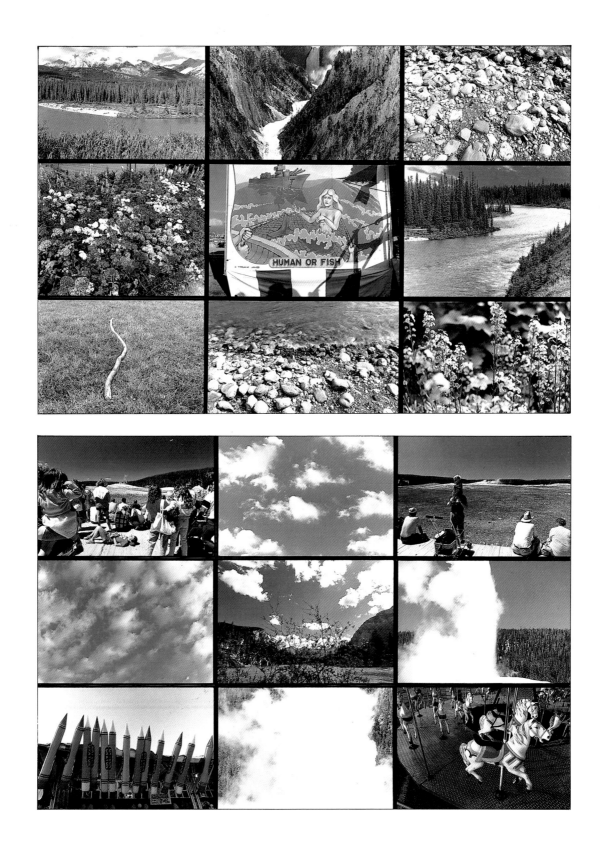

無止境（上）（下）——Infinity (up) & (down)　　144×97cm (each)　C-print 彩色照片　1988

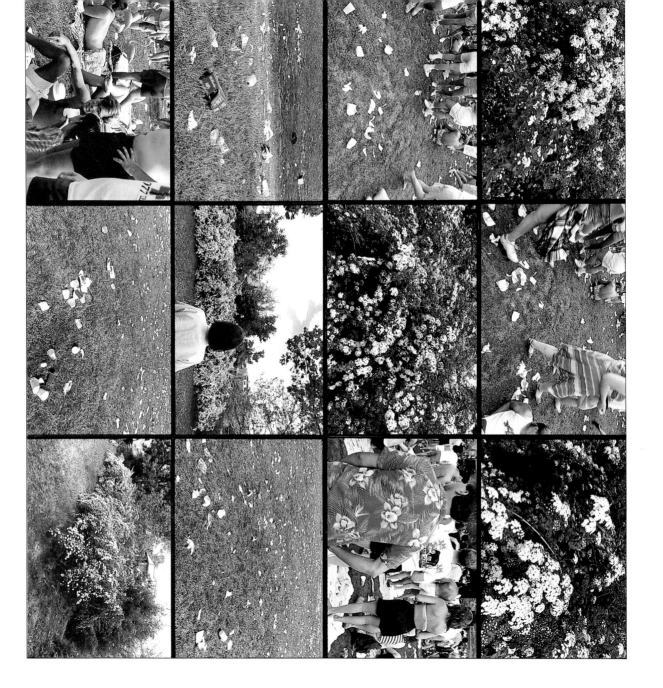

五月花二號 ——May Flower II 288×130cm C-print 彩色照片 1988

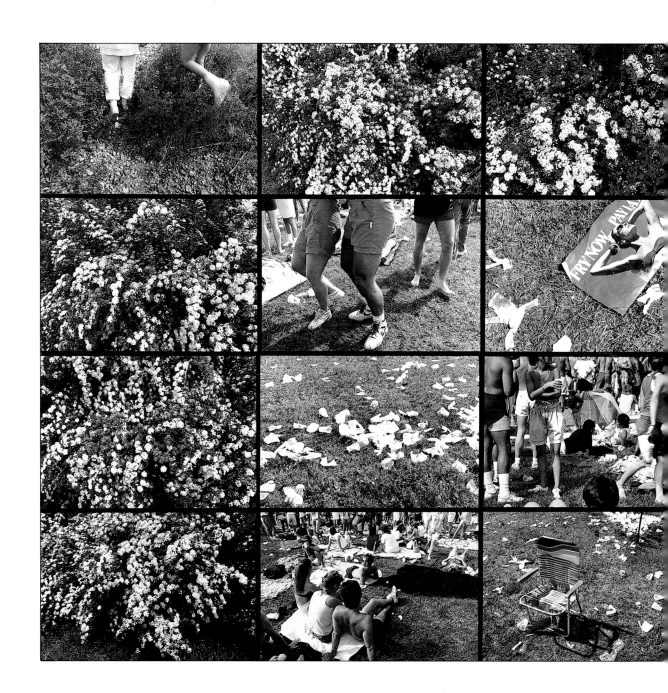

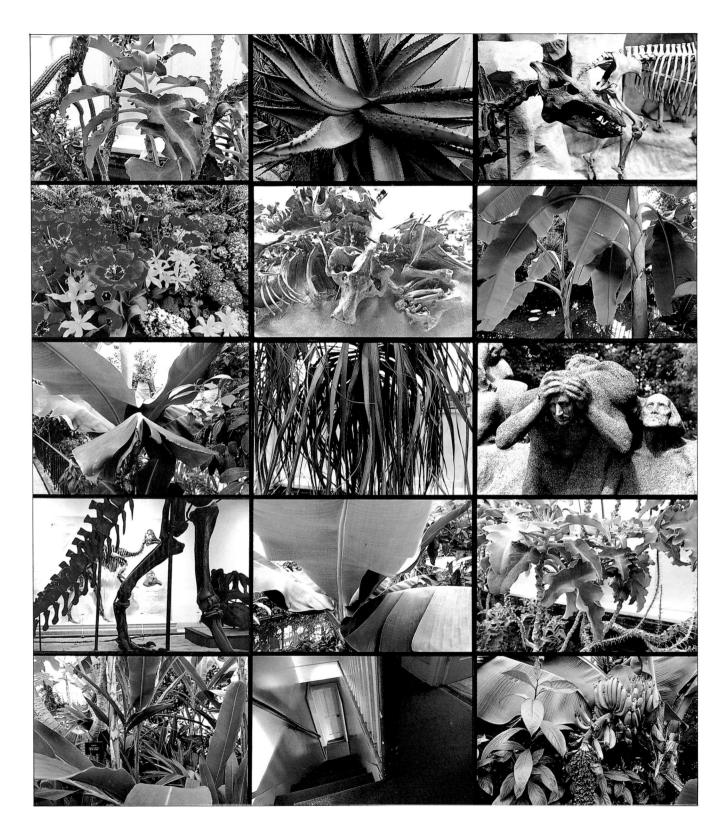

恐龍下樓梯——Dinosaur Descending a Staircase　　164×144cm　C-print & B/W　彩色、黑白照片　1988

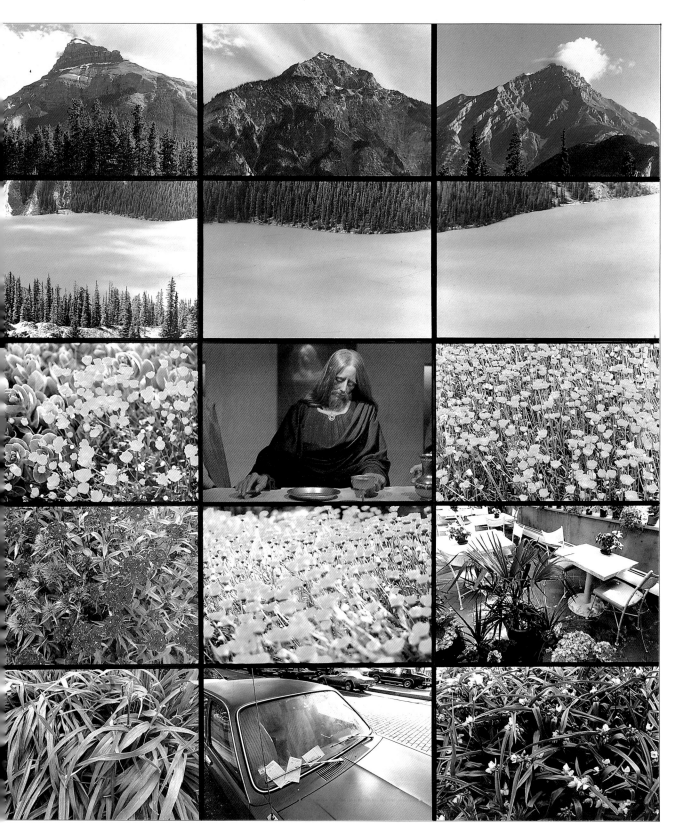

蘇珊的日記第三十六頁——Susan's Diary Pages 36　　240×195cm　C-print　彩色照片　1988

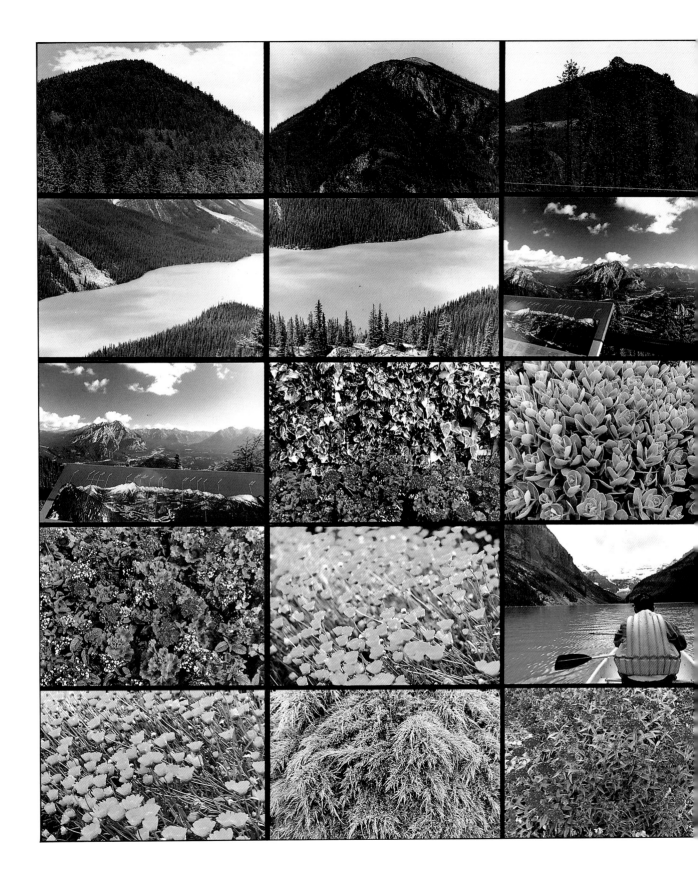

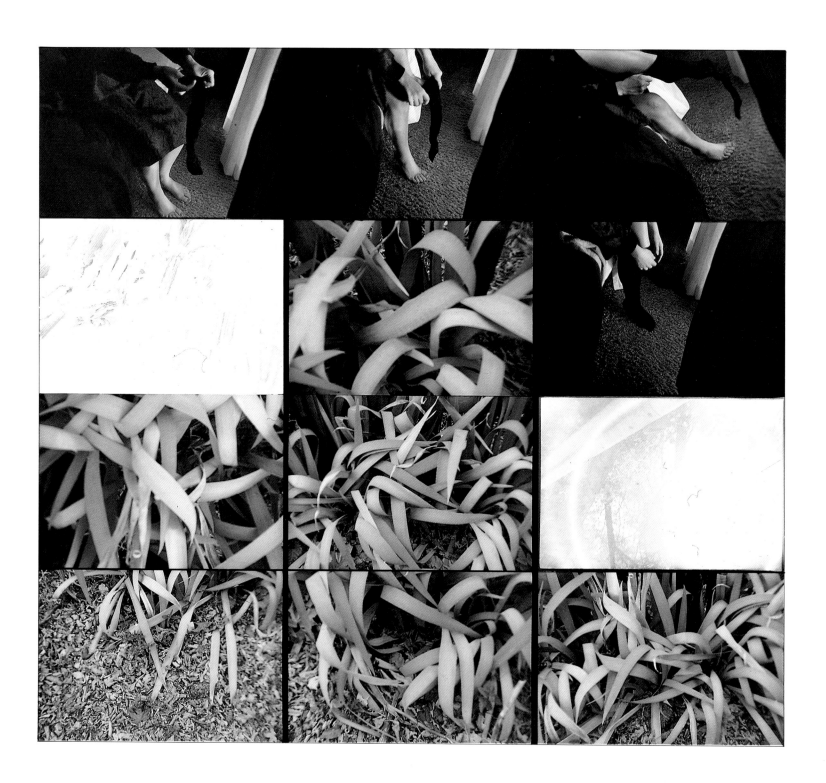

五支黑襪子——Five Black Socks　　144×130cm　　C-print　彩色照片　1989

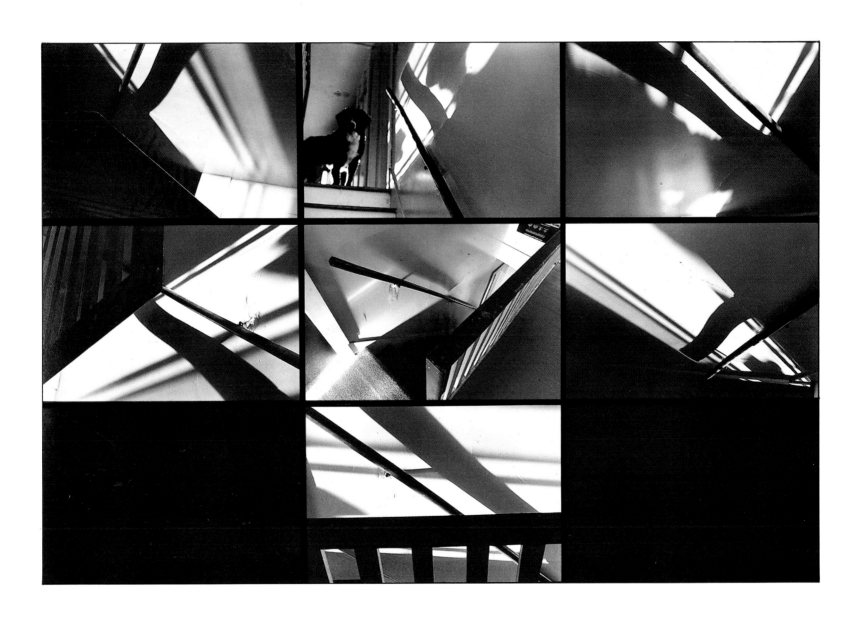

黑狗——Black Dog　　144×97 cm　B/W 黑白照片　1987

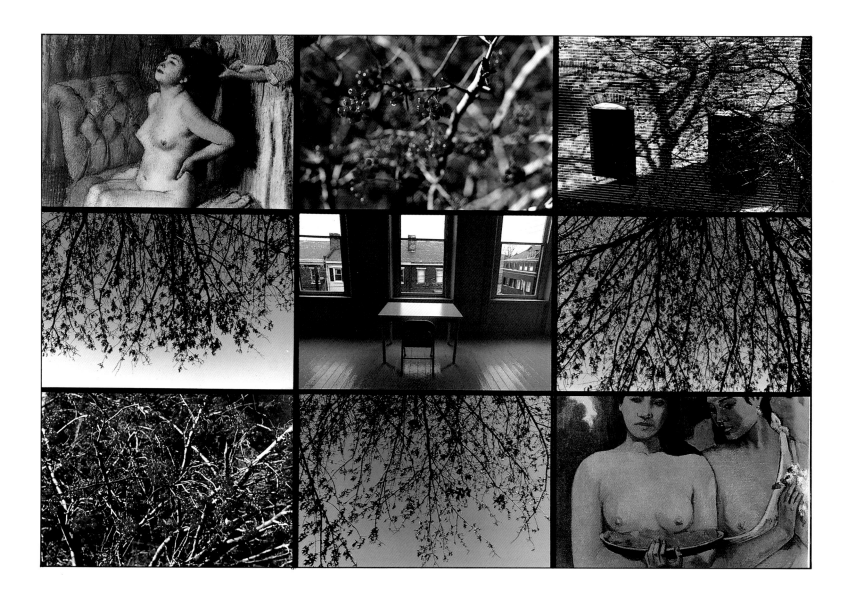

有關於高更——Something About Gauguin　　144×97cm　C-print　彩色照片　1989

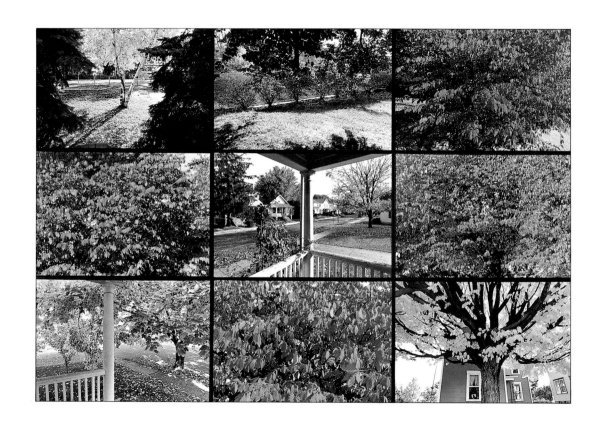

紅色染料No.4—— Red Dye No.4　　144×97cm　C-print　彩色照片　　1988

modernist's cult of genius and he would subsequently be the person enabled to grasp autommomous chances of supremacy. While his confidence seemed to conceal the modernist's contradictory essence, his languages of aestheticism chorused with the palpitations of an uneasy heart. Ben Yu was very different from those western postmodernists whose works reflected the abruptness of sudden ejaculation from the head of an erectile inclination which had risen to the depiction of mundane realities. Ben Yu has here thus conveyed his concealed and idealistic longing for a perpetuity which truly belonged to oriental antiquity.

 * * *

Yu's composition "Fruit Shots" was comprised of eighteen panels and seemed to follow a numerical sequence according to the fruit arrangement. Fruits were dispersed on geometrically (almost rectangularly) shaped grass-grounds. The cast shadows of human figures implied games in process. But when viewers tried to sort out the rules of the games, they would find themselves puzzled and in a vacuum like the fruit shots in the plastic bags.

In "Red Dye #4" the viewer's stand-point coalesced to the center piece, as if the viewer had used multi-range cameras to snatch pieces of scenery from surrounding areas. These person-less scenes strongly implied a person's fixed view-points. The red maples, yellow leaves, green trees and little white houses set in rhyme a pensively refined string quartet concerto.

In "Moving Red," the viewier's attention skipped along a series of "reds:" red tulips, red T-shirts, a red curtain, a red painting, and a red fire-extinguisher switch until a black and white portrait of Andy Warhol interrupted the red moving flow. In the gallery itself, the small gathering of people contrasted with the quiet gallery space and the lone corner of a room. Sunlight, meanwhile, contrasted with the "only existence" of the yellowish glow of lamplight which seemed to transmit from another time and other space. That "only existence" of yellowish illumination brought out Warhol's image which touched off a sudden emotion of sadness and mourning.

"Shrivel...Pull" compelled powerful theatrical temperaments. The figure's actions were as if they were freeze-frames from the motion pictures. Fluorescent light on the wall and fallen leaves enhanced a lonely and desolate state of mind. The alterations of positions and shooting angles indicated time-motion continuities of a story. Yu's handling of the colors created a content of "airy" and "illuminated" motions in his photographs. "Shrivel...Pull" were eloquent still motion pictures in series.

Like "Shrivel...Pull," "Hello, Is Susan There?" contained rich theatricality but its segmented visual verses did not give out clues to the inquiry.

"Nineteen Photo-Graphs" was of much interest in that it was actually only composed of eighteen photographic panels. A photographer's shadow was cast on each of the seventeen pictures except the second picture from top, the third from the right contained only a stone sculpture of a human figure. That nineteenth photograph was created by the viewer himself casting his own shadow onto "Nineteen Photo-Graphs." Therefore the completed nineteenth piece would be accomplished

with the participation of the viewer, a conceptual idea of some whimsy.

For "Chicago Map C-5," the title itself pointed out a specific map location, and extending the map motif, color lines further divided those fifteen picture planes to build up a tension of "motionlessness and activity" which contrasted the assemblage with the viewer's interweaving eye contact.

In "Flapping Cardinal," there was a carefully wrought two rolls of what seemed like cement tile images on the far right and bottom of the piece, as if viewer were looking down a flower bed or looking out from a door or window. Green grass echoed the green trees but were shot from different angles. Such a combination of "temporal" and "spatial" transformations-- a mixed perspective, with wind motion and woman in exercise, added an appropriate black and white sculptured image which reminded viewers of a television screen video wall of various pictures and images all displayed at the same time.

The only piece of social criticism in this exhibition was "Mayflower II. White flowers inhabited by white trash papers and green grass trampled by white shoes subtlely exposed human carelessness in sabotage of the environment.

With a touch of Duchamp the "Dinosaurs Descending A Staircase" placed photographs of green shrubs in correlation with images of black and white dinosaur corpses and staircase photographs. A stone sculptured man buried his head in his arms to announce a premonition of disaster: a dinosaur descending a staircase --an inevitable smash. Here, Yu inserted an image of abundant flowers in full bloom to honor the dead corpses employing a comical metaphor to explore a living crisis withheld like a prose poem and thus rounded off the exhibit.

 * * *

In general, Ben Yu's exhibition of photographic work revealed a consistent affluent literariness and this strong narrative inclination diluted his intention to investigate his conceptual ideas of a three dimensional installation structure. But his arrangements and assemblages of smaller individual units of visual languages were intersected to interrupt continuous narrations. He therefore accomplished a spatially visual conversation with his photographic installations to provoke challenges toward the traditional notion of fine art photography. His choice of photographic medium in the manner of embracing the variables will once again prompt another phase in another time.

Ben Yu has presented an untarnished aloof character of his work which reaches beyond this mundane world. In this chaotic and orderless era, his unique quality should not contend with distractions and degenerations.

Victoria Lu

AN ENCOUNTER OF RESULTANT IMAGES IN SPACE

It was the British artist/inventor Henry Fox Talbot who successfully developed a positive/negative system in 1839 which enabled the production of unlimited duplications of prints from a single negative. This system is still in use today, and, available to the vast popular demands of the mass consumer market of the 20th century, so became the greatest anathema of fine art photography. The proliferation of such non-art photography as family album snapshots, news photos and commercial advertisements created in modern artists an acute awareness of and vigilance toward this pedestrian form of the photographic image, and they felt it necessary to carefully draw a line between it and their own work.

In order to distinguish fine art photography and non-art photography, early fine art photography camouflaged itself under the guise and imitation of styles, subjects and forms of paintings. These anti-technological and pro-manual skill prejudices were embedded in the notion that natural endowments could only be possessed by geniuses. An orthodox modernist doctrine of "l'art pour l'art" was eventually derived from the artists' consciousness of self-reverence and self-defense, which led to a deductive mode of "pure' art. For more than half a century, this doctrine of "purity" presided over the direction of modern photographic creativities. It wasn't until the 70's that a new cycle brought fine art photography into a new domain: that of the "postmodern."

Postmodern photography originated in the 60's from those Pop artists who altered their attitudes toward the application of photographic images. Pop artists boldly used mass media images to reflect the consumer culture of commercialism. They directly plagiarized photographic images from television, magazines, newspapers, advertisements and bill boards - a new beginning of a "Postmodern" phenomenon. A flood of mass media images stimulated the experiences of "simulacra" (without originalities) that unveiled a new era created by electronic interdiction.

Artists in the 70's generally abandoned the previously-held modernist esthetic of "purity." Rather, they experimented in diverse forms and directions with pre-existing styles and media or with yet new styles and media. The result was like a touch of flame that engulfs a dried grassland in wildfire, and their dismantling of the boundaries of style and media quickly swept through the entire artistic domain. Anti-modernist impetuses were expressed in a variety of extremely individualistic forms: Body Art, Performance Art, Conceptual Art (including conceptual installations), Happenings and Earth Art (Land Art), upsetting the modernist pursuit of a utopian universality which long had supressed individual emotions and feelings. To document these activities, most of which could not be viewed in museums or more than once, photography was the tool used and it soon became the only representational evidence of the execution of these concepts as well as the most faithful record of them after their disappearance.

Thus admittance of photographic work as an integral part of these creative concepts led to the beginning of a new chapter in postmodern photography. The appearance, then, of postmodern photography in a multiplicity of styles and media-mixes logically followed the dismantling of boundaries in the fields of painting, sculpture, drama...etc. Its artists began to freely use photographic techniques no different from a draftsman's pen, a painter's bucket of paint or an earth artist's slab of rock. They no longer excluded narrative content and were frequently quite willing to depict metaphorical stories. Photography gave up the examination of the question "Is it real?" which was now supplanted by the search for "Which reality is it?"

Postmodern photography, then, no longer reflected unhumanly diefied solitudes but expressed the pressures, tensions, and emotional turmoil of individual reactions toward the reality of life. Images were manifested in the torn experiences that cannibalize with fragmentations. Authority was eroded and eventually lost if not annihilated in the exceedingly commercialized environment that was governed and subverted by the mass communication media. The originality of creative forces was inundated by the swarm of simulacra.

Photographers, like artists of other media, would not necessarily be just recorders who pressed the "decisive" button of camera shutters. They swam in the sea of simulacra to grasp, or to contrast, chances by resultants, or to appropriate existing realities, or to recreate a seemingly thaumaturgic phantasmagoria from realities. Photography, in essence, became the common language of common livelihoods in a postmodern society.

* * *

Ben Yu is an artist who spent his formative years in an oriental cultural environment but reached his maturity in the West during the decade of the 80's. An exhibition of his photographic works spontaneously reveal the pluralistic factors of his influences and their compounding by the collision of his two cultural backgrounds. "Straight photography" could not satisfy his creative desires, and so he extended his works into three-dimensional space and his concepts broke away from the limits of the modernist's pursuit of "flatness."

His works, as exhibited, were all combined by multiple panels. The works were installed in a distinct room space to segment a new relationship of foregrounds and backgrounds. Viewers could walk around the pieces to activate the multiple combinations of newly contracted visual conversations. It was evident that his works had stridden over the boundary of straight photography, like his postmodern contemporaries who manifested "impure" characteristics where "idea" itself became extremely important. These art works were exponents of reactionary responses to the environmental conditions of which the viewers reactions toward art works themselves were given equal importance.

The inexhaustible possibilities implied in Yu's works indulged him independently away from traditional and documentational representations. Their courses would be dynamically determined by the different factors of viewers, times, and places and would shift for each and every occasion. The continuous possibilities of combining multiple images indicated seemingly endless linguistic choruses. Prediction of outcome was as difficult as playing the lottery. His individual single panels still depended on "decisive moments" which were not photographed from pre-set circumstance (except the "Fruit Shots" piece).

It is clear that Ben Yu's esthetic was deeply rooted in the

November 9, 1988

A Critical Letter of Reference for Ben Yu:

Ben's exhibition photographs offer significant cultural, coloristic, and iconic excitement. His image arrays and the three-dimensional presentations offer interesting and complex solutions to the usual limited effects of small scale and lack of physical solidity inherent in photographic art.

The arrays present aesthetic and cultural dialectical possibilities for the viewer which are neither quickly nor easily solved. These assemblages of multiple prints can be read as color-field investigations (with vigorous and significant uses of strong red, a cultural carryover from Ben's Chinese inheritance, seen for itself rather than as an indicator of violence or as a political mnemonic). They can be examined as unusually witty and vigorous investigations of space. They can be seen as reexaminations of unfolded space or as form and color, reflecting minimalist concerns. Or they can be examined as notebook summaries of an artist's response to the American landscape of the moment. The complete body of work includes three-dimensional arrays which invite contemplative examination of implied and actual motion as well as implied and actual color.

The scale of the three-dimensional and the flat assembled arrays permits a response to the photograph one usually finds reserved for paintings, and previous assumptions about correct photographic viewing distance are immediately discarded. Added pleasure is to be found in the fact that each picture element within an array is also a well seen, competently crafted complete statement in and of itself. This visual richness discourages facile viewing, often the hallmark of photographic exhibitions. One is encouraged to study the pattern of the entire array, walk up and explore each individual picture for detailed, inner content, then step back and begin again. The rewards are significant.

Sincerely,

Arnold Gassan, Ph.D.
Photography Chairperson
School of Art
Ohio University
Athens OH 45701

ANALYZING IMAGES

Match-makers' photos, indentification pictures, and newspaper photos all serve to indentify; and yet, is the photograph truly representative and convincing? The picture of man is but a fragment in the whole course of his life; thus, it is impossible to represent the whole life of a man through a single photo. A single photographic image is more representative than primitive pictography, of course, and even single images, a picture of a delicious barbecue, for example, can bring an appetite to a man, though never to a dog. In actuality, we believe in the reality of the single image, even though we know that a scene of daytime must become a scene from the night, if the camera's exposure setting were insufficient. An up-angle shot would make the image on a hill look like one down on a flat plain without the proper craft of the master photographer.

A young Chinese photographer from Taiwan, Ben Yu, is aware of and is questioning the reality of the single image, a reality that most of us believe in. Ben Yu, having returned to Taiwan after studying for five years in England and in the United States, controls the beauty of form and color in images, and yet is not satisfied with the beautiful image in a single picture. Instead, as an artist, he arranges groups of pictures to recreate a composition and achieve multiple aesthetic effects. Ben Yu employs images to analyze images, even to criticize them.

For example, his "Nineteen Photo-Graphs" contains eighteen pieces of photography, laid out over the ground. These eighteen pieces add up to nineteen pieces because of the participation of the audience's shadows which are part of Ben Yu's creative purpose. The photographic sculpture, enhanced by the viewers' shadows falling on it, creates a trick with images which is just short of incredible. Ben Yu seems to be saying that an image, like a sign, only has a surface after one touches it--or questions whether it is aesthetic wisdom to compare a flat surface to a real object or to one having three dimensionality.

Ben Yu's twelve pictures of fishes suspended in spiral form in space, depict the suspended images as a group of fishes swimming easily around. Yet, if a viewer looks at these from the side, he finds them as surfaces of images without real depth. The artists pictures on both sides of a board are presented differently; one in color and the other in black and white. This particular manipulation produces quite a different feeling in the viewers, and at the same time, reveals the ambiguity of the image itself.

Ben Yu's creations persuade the appreciative audience that one should be aware of the truth of reality that images present no matter whether one believes in humanism or aestheticism, because an image can be varied in itself when perceived from various angles. Ben Yu believes that in order to pursue the true reality of images, one should not simply frame them for the sake of the beauty or good that they seem to carry. The artist should not apply color because he is happy, and apply black and white because he is sad. Instead, the challenge of the artist is to neutralize images when he confronts them. Ben Yu devotes himself to this kind of expression and has equipped himself with fresh concepts in art.

Lu Chin-Fu

BEN YU
PHOTOGRAPHIC
CONSTRUCTIONS

1988美國Ohio Seigfred Gallery.